A SUMMER'S DAY

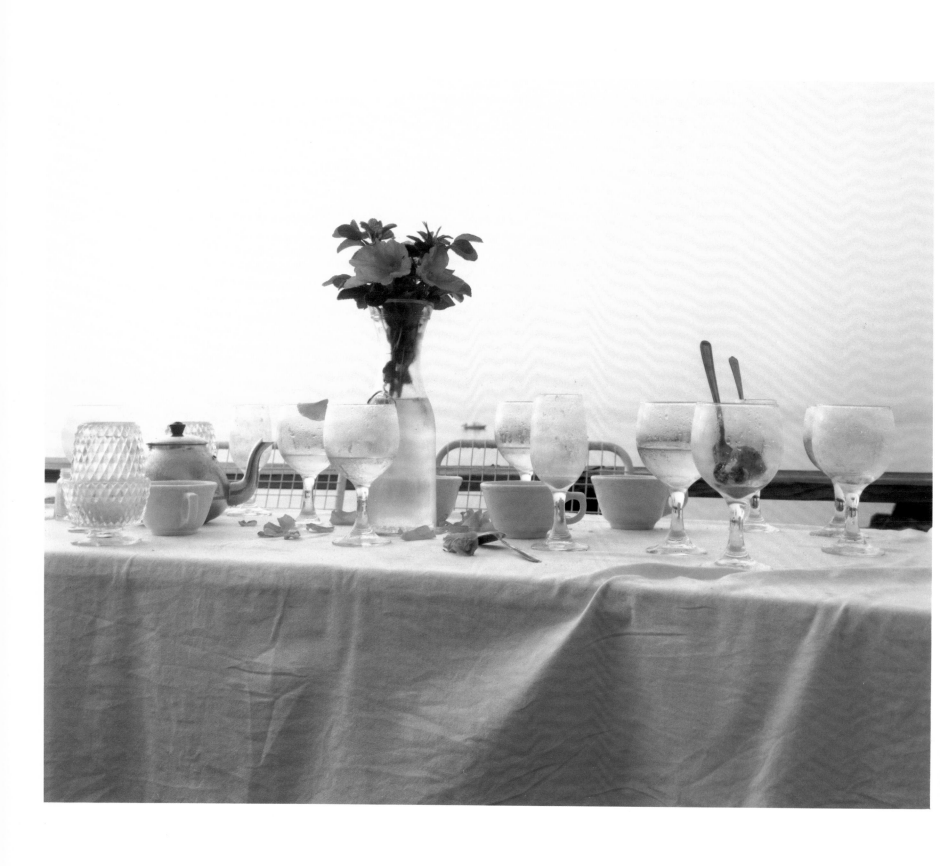

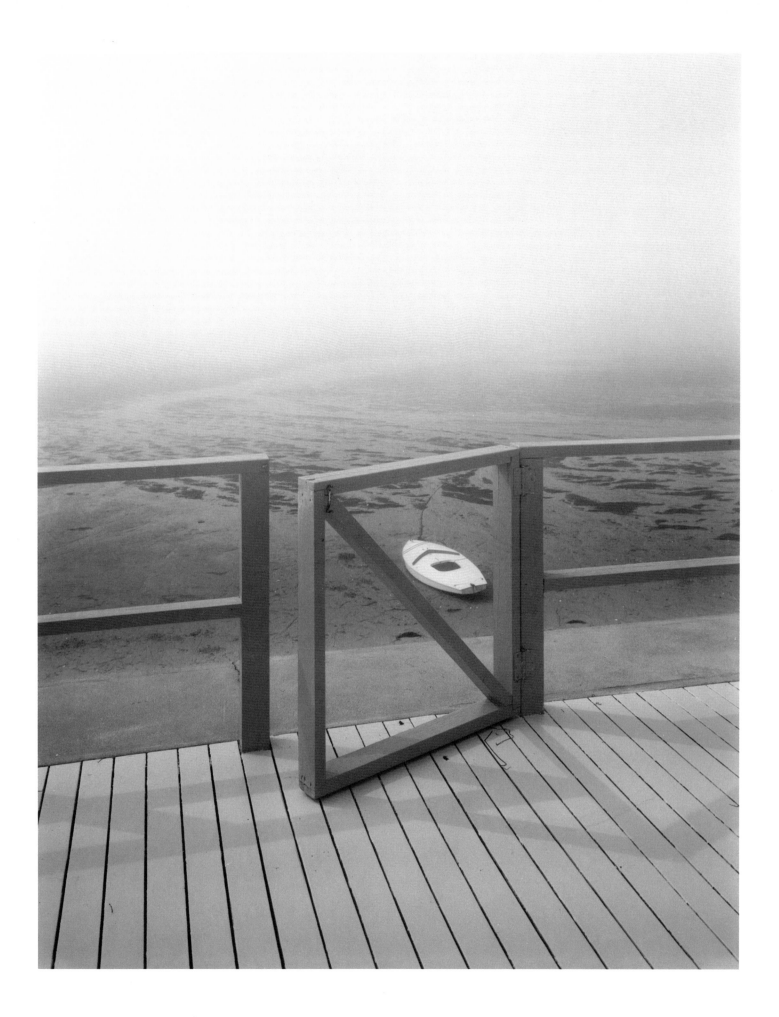

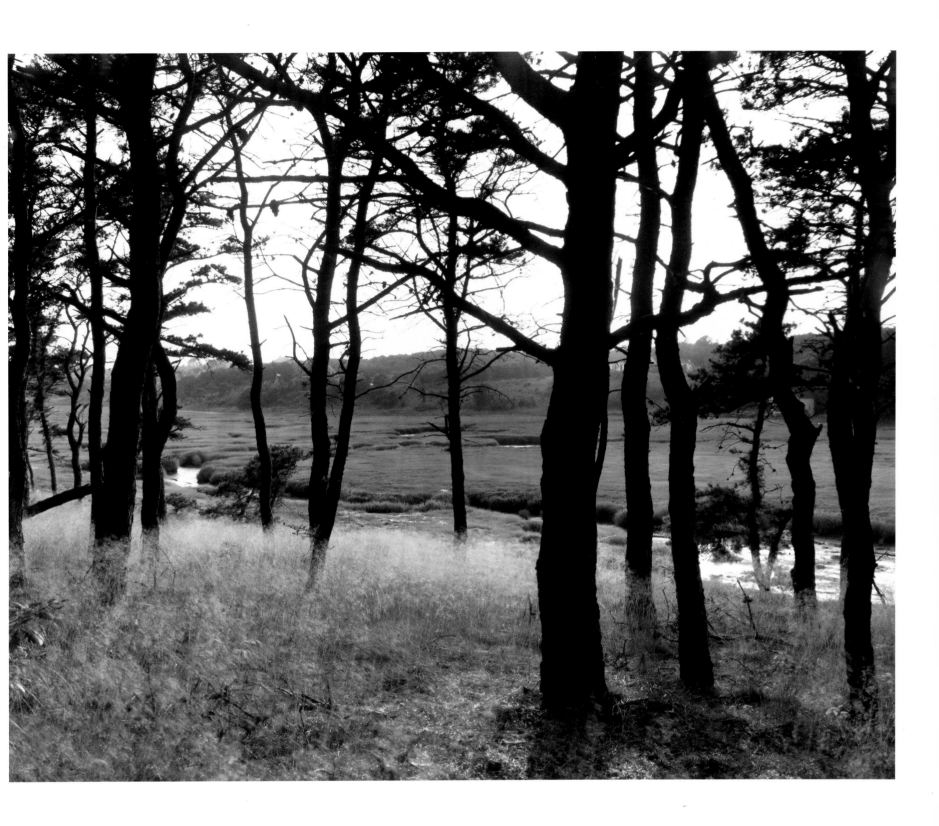

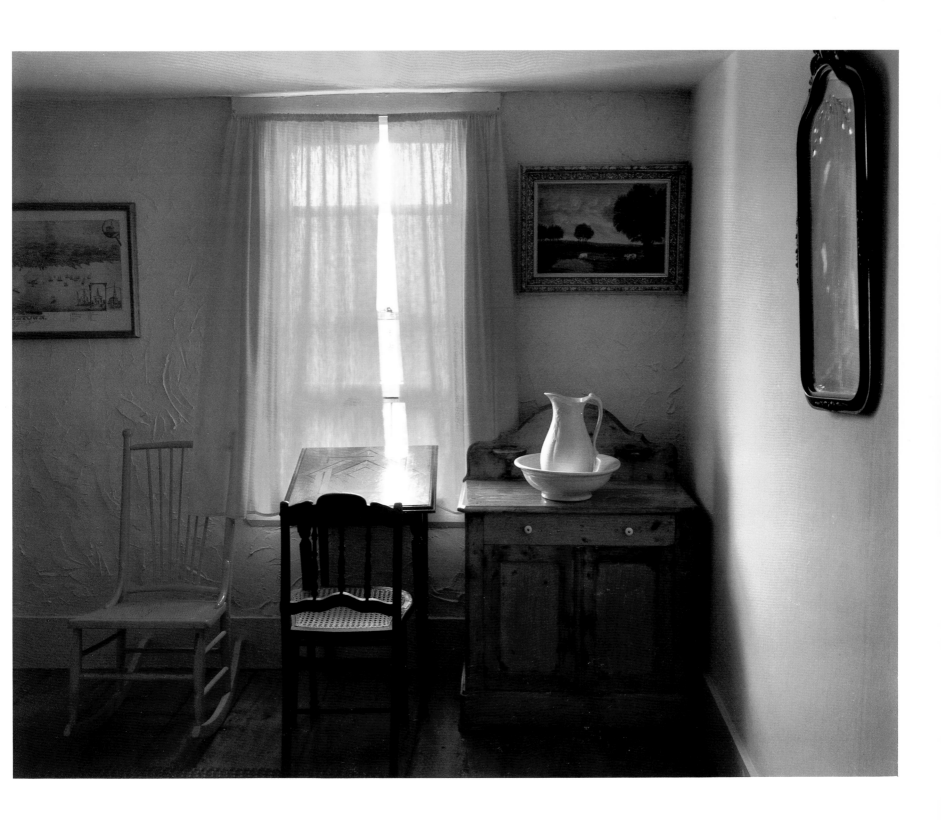

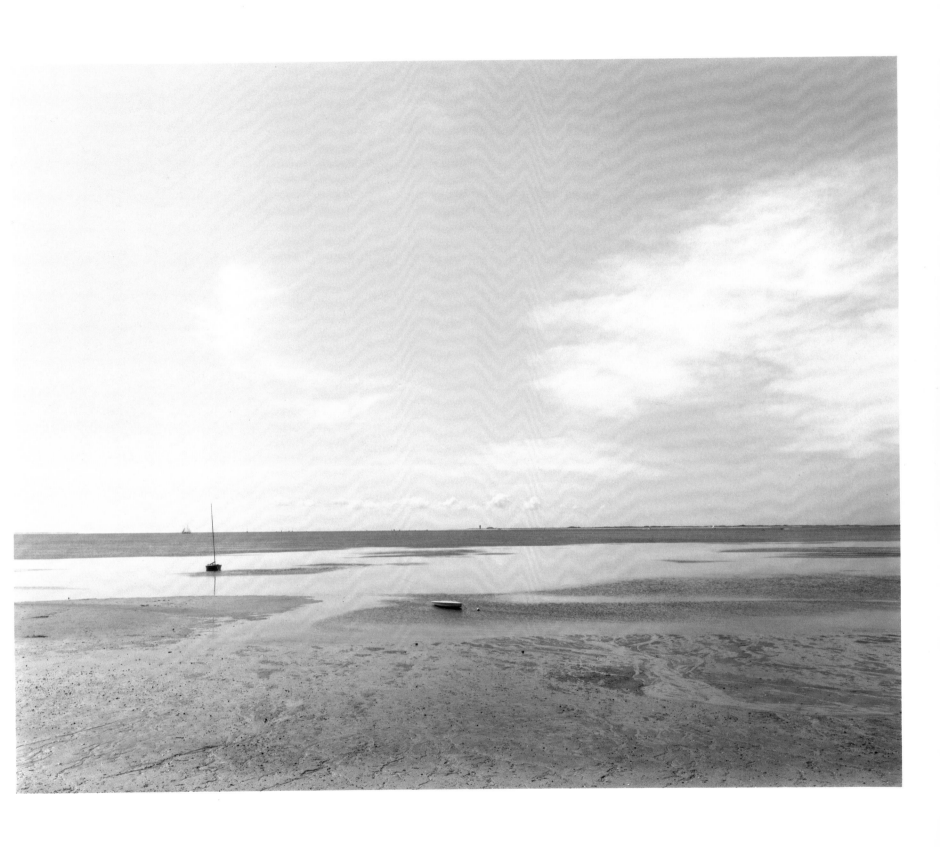

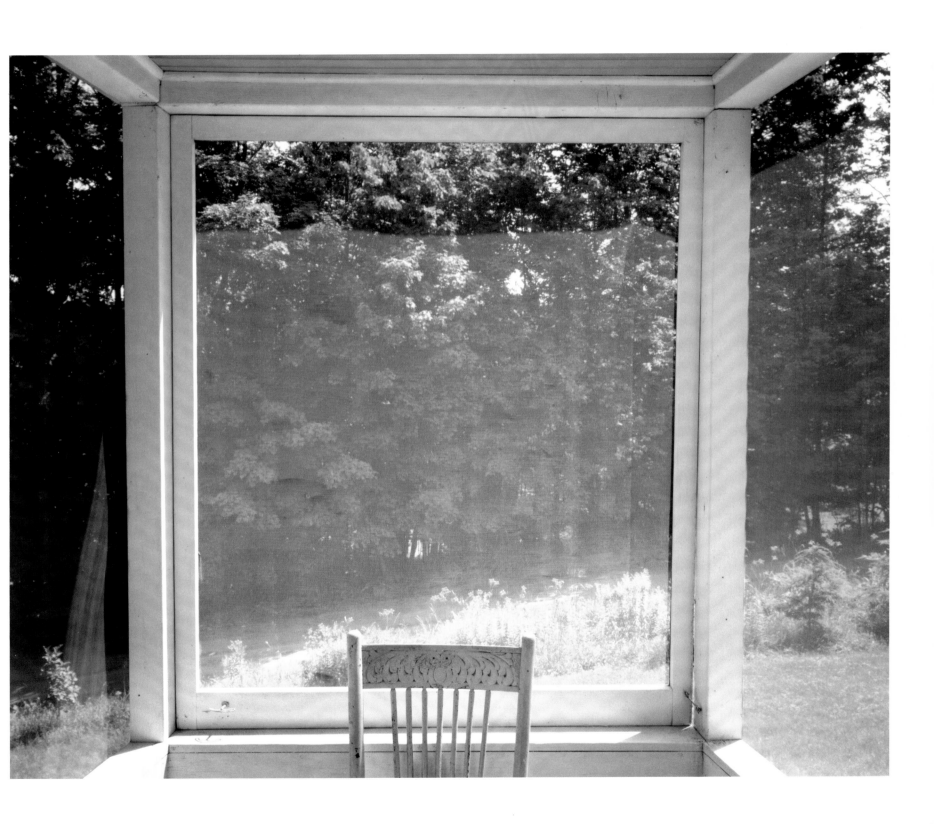

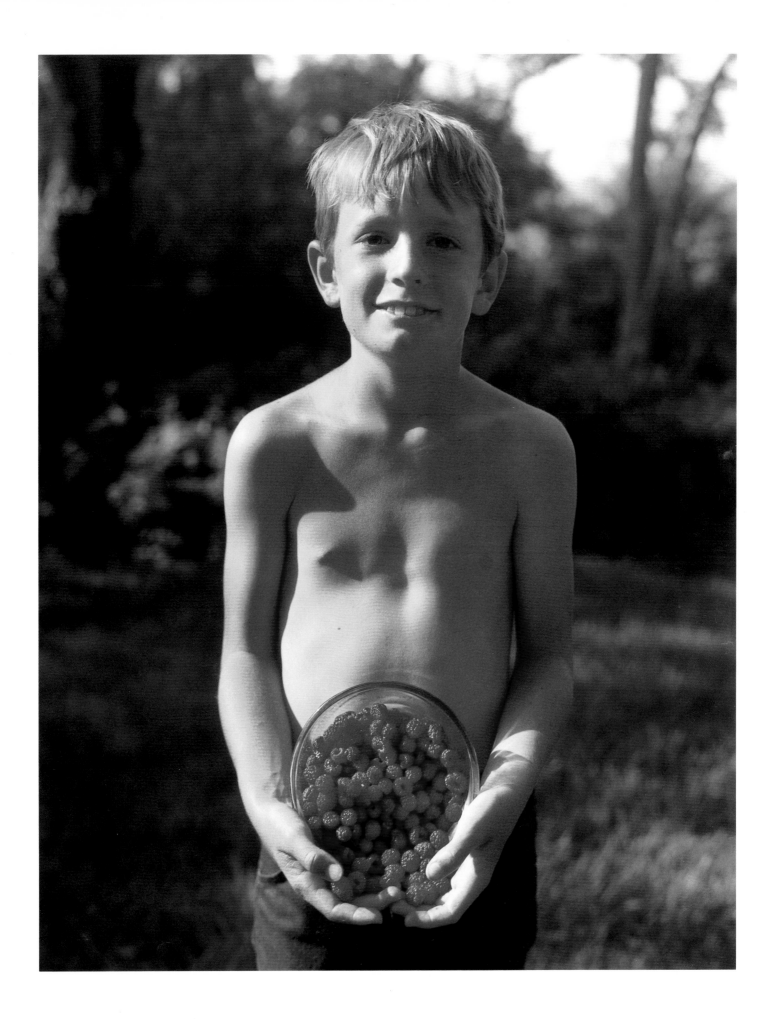

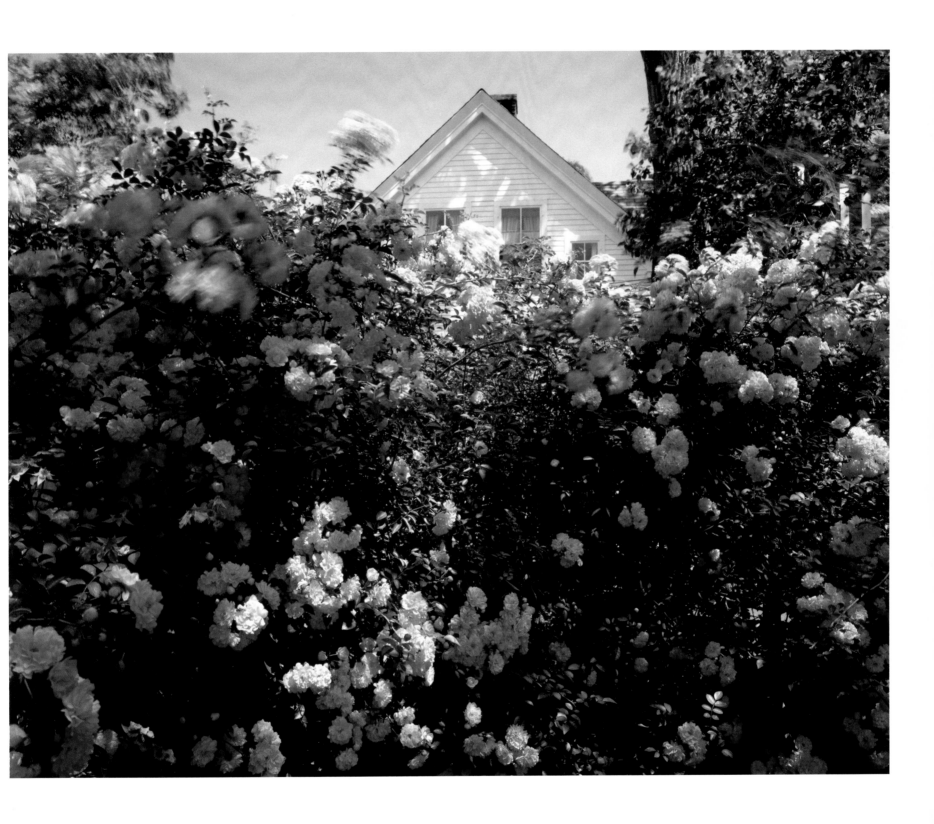

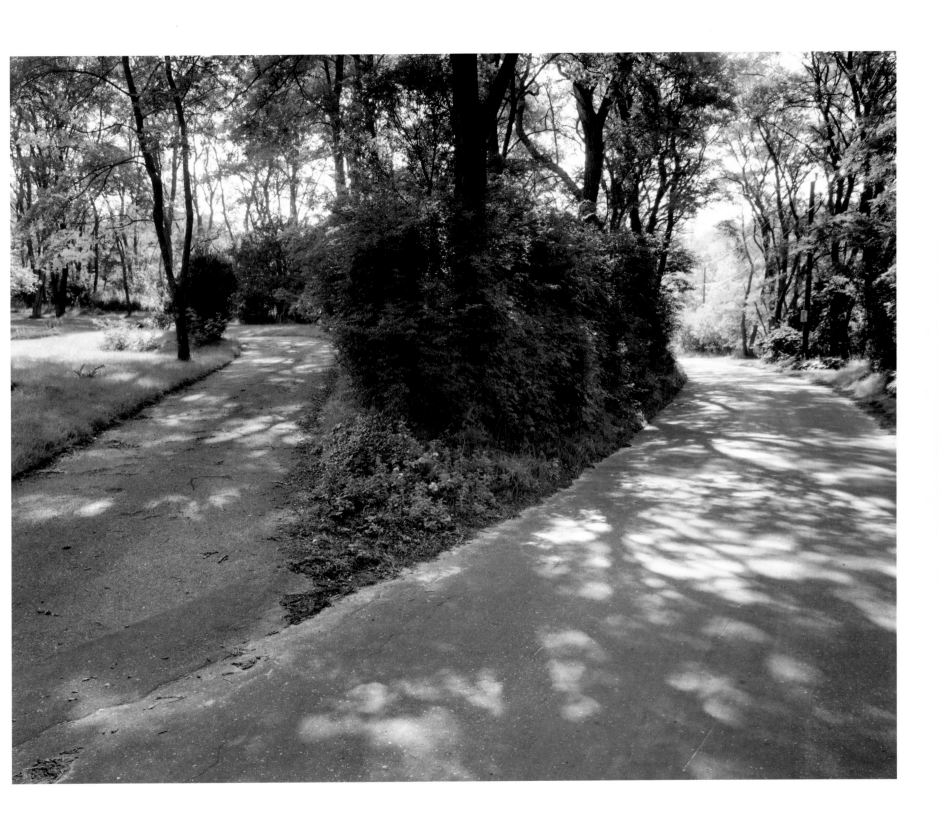

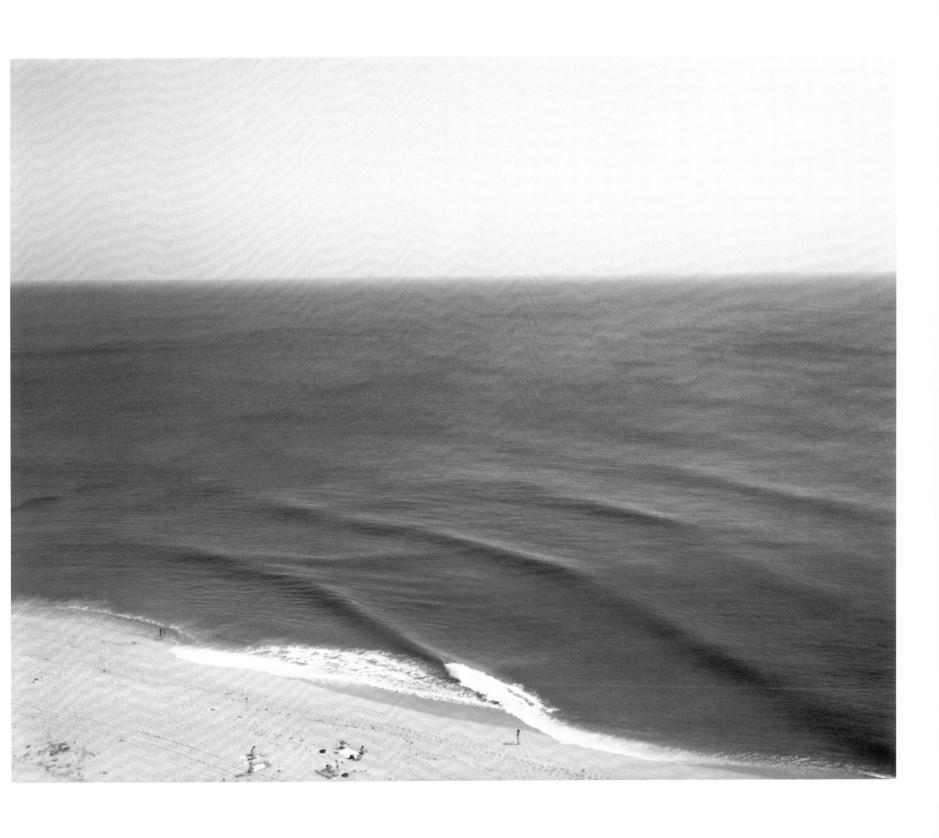

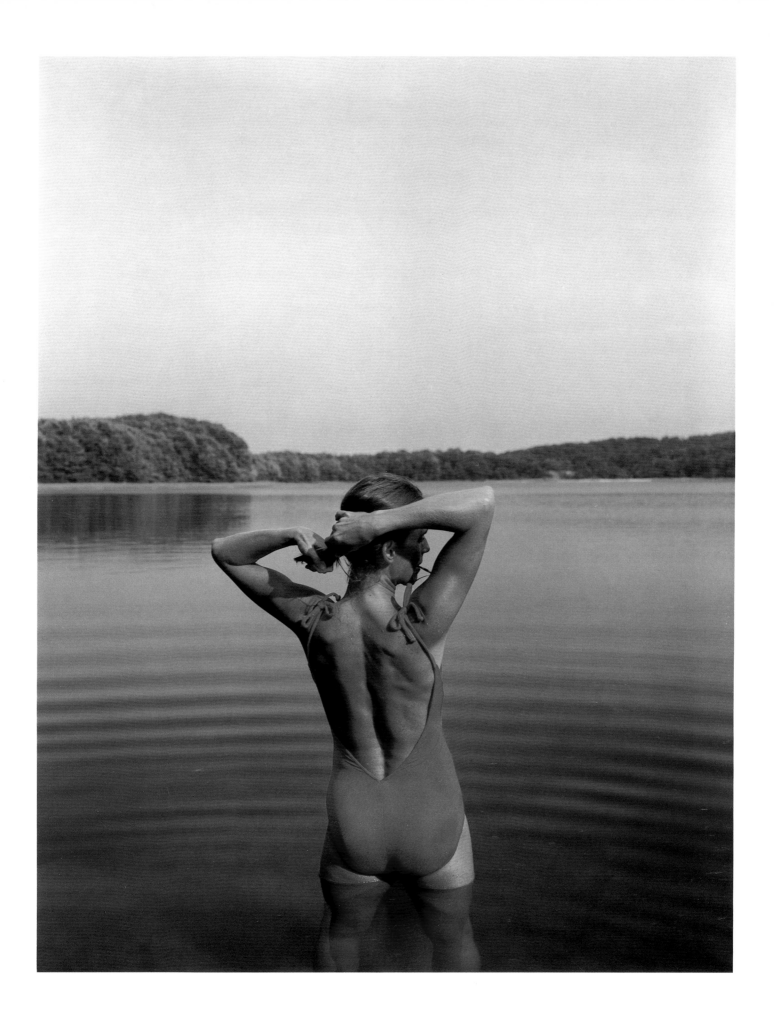

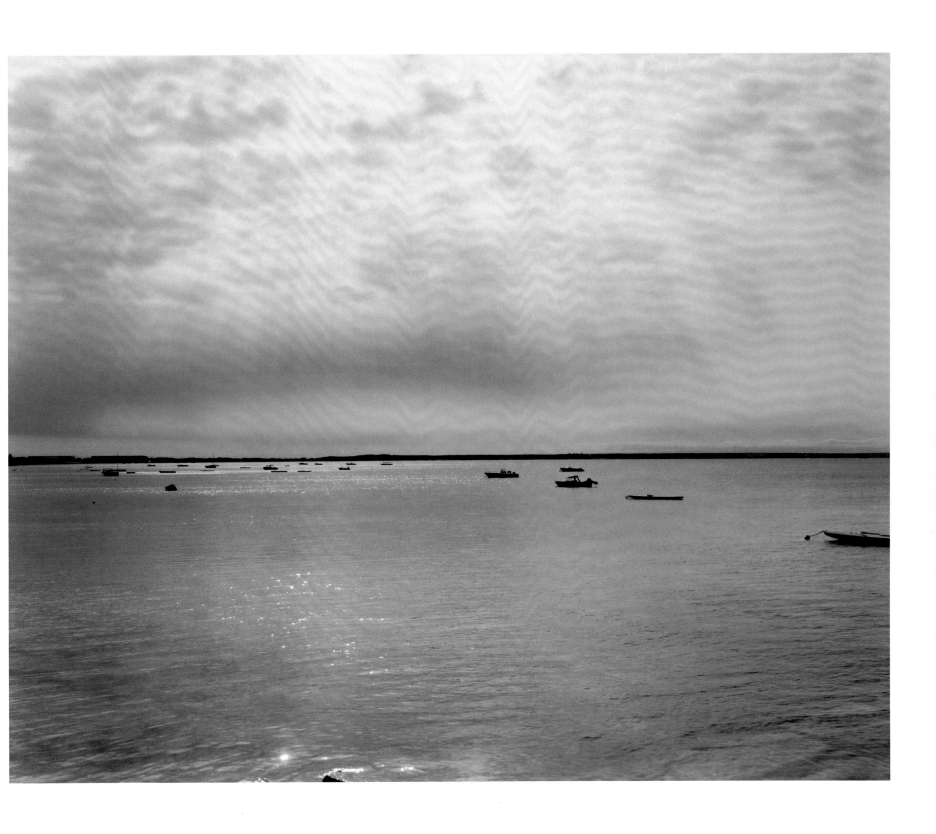

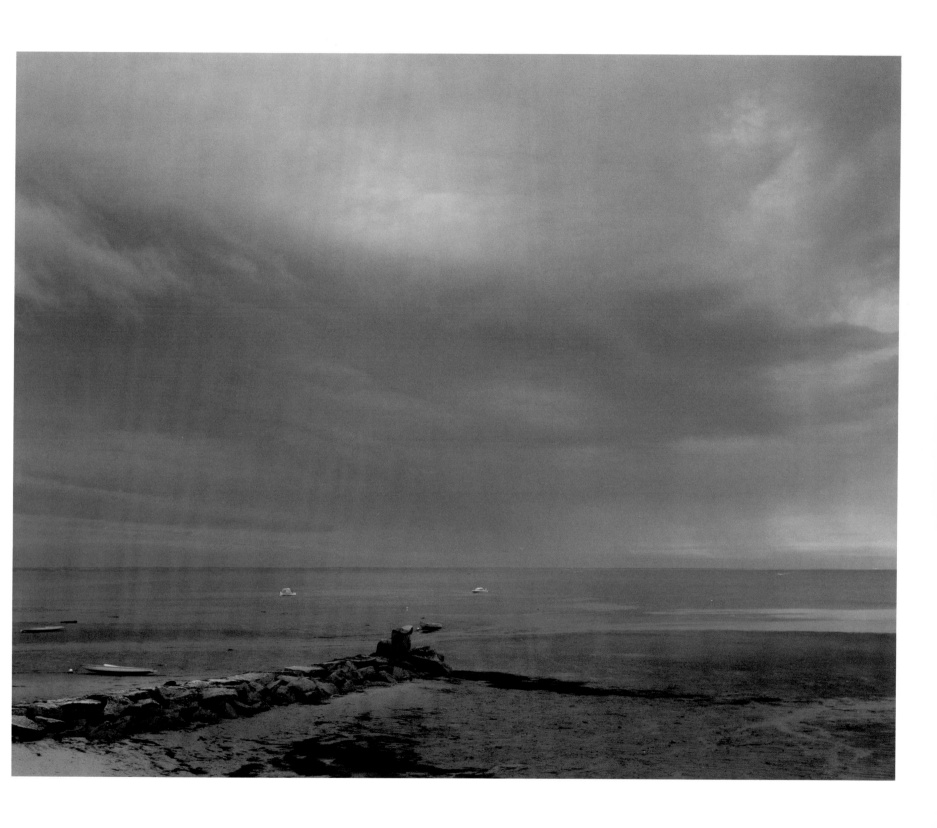

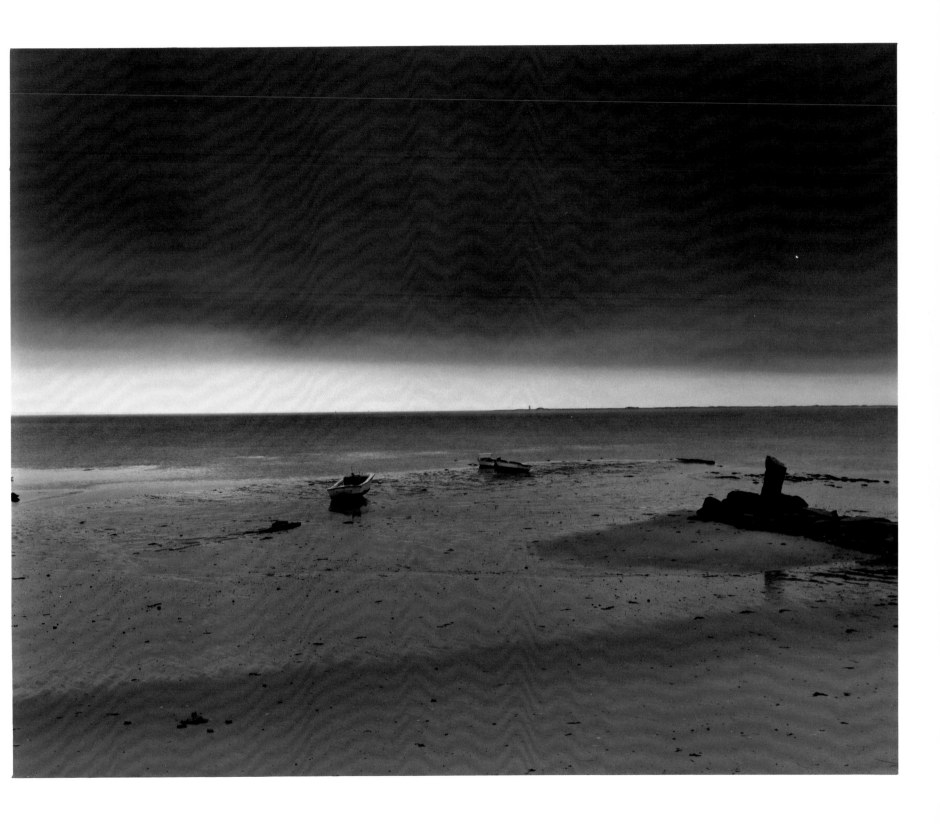

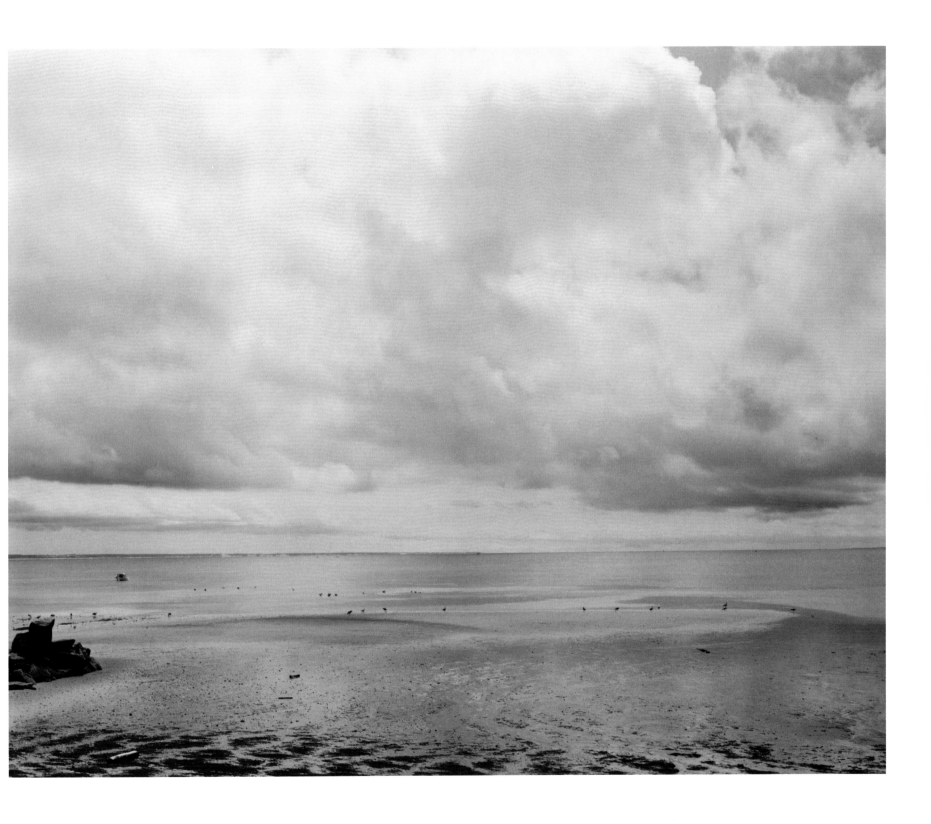

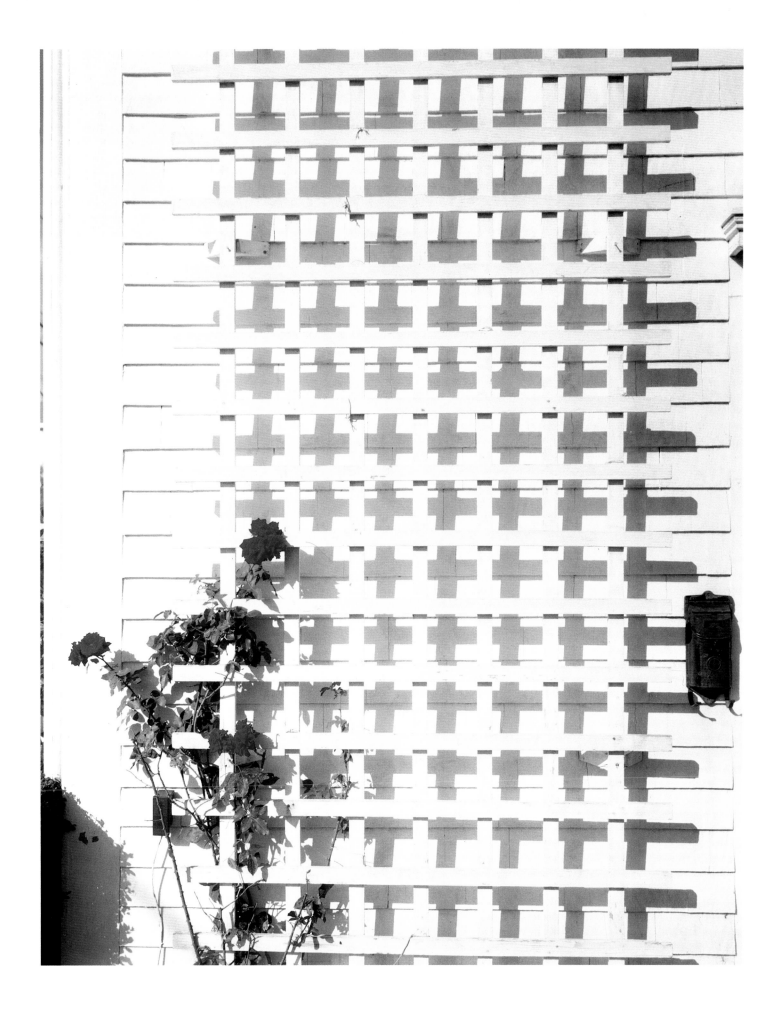

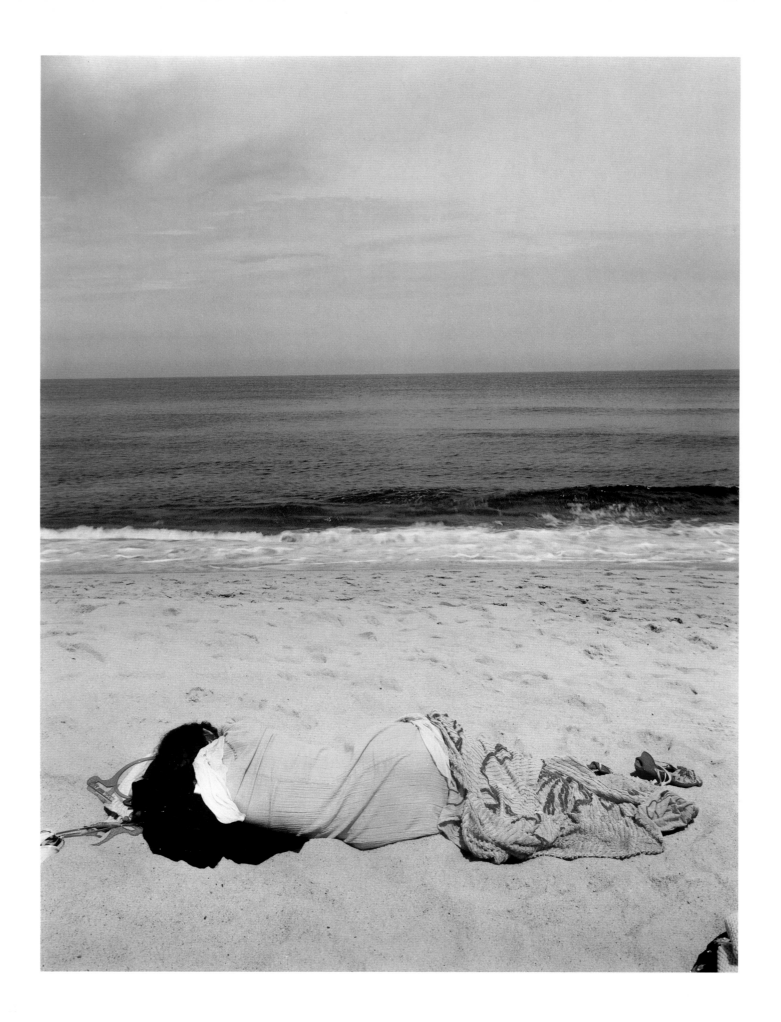

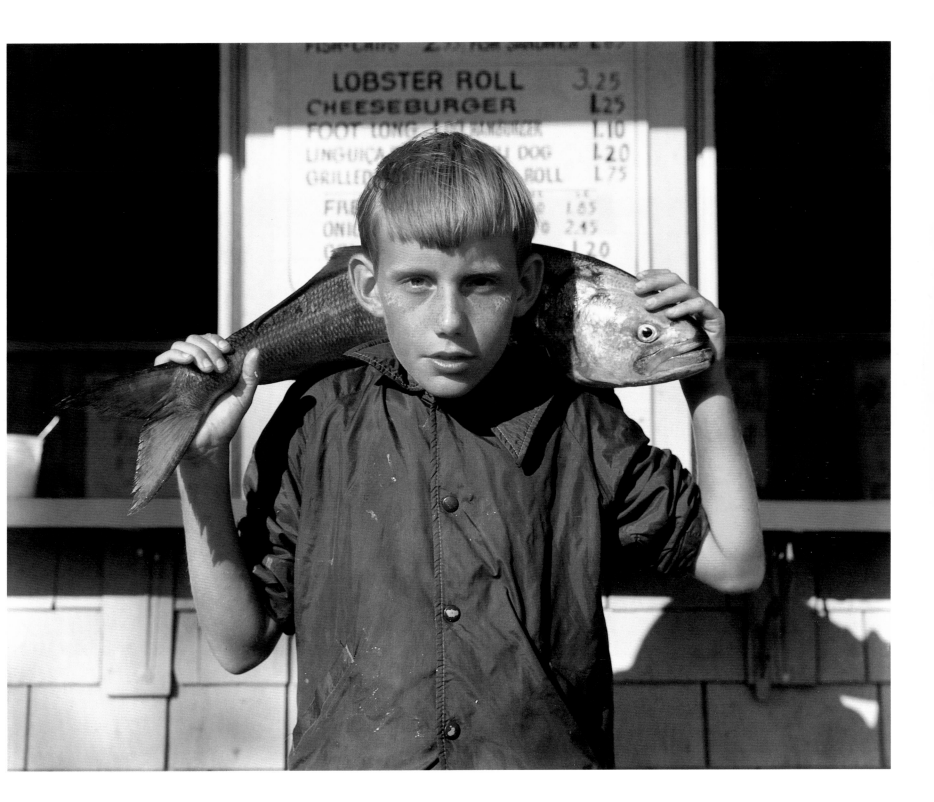

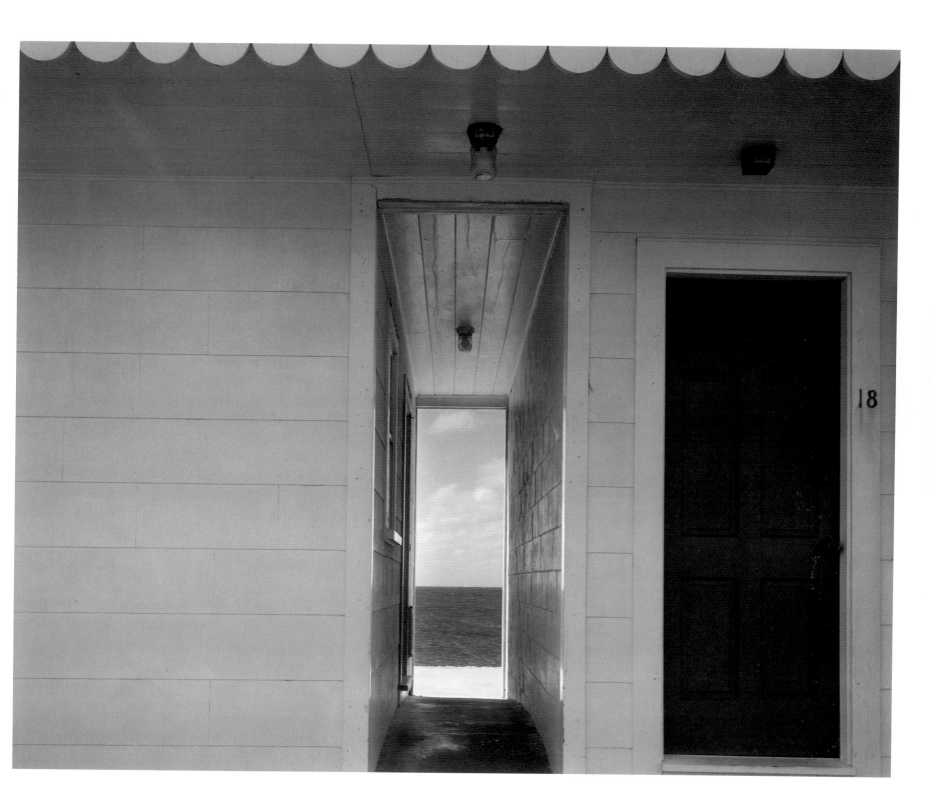

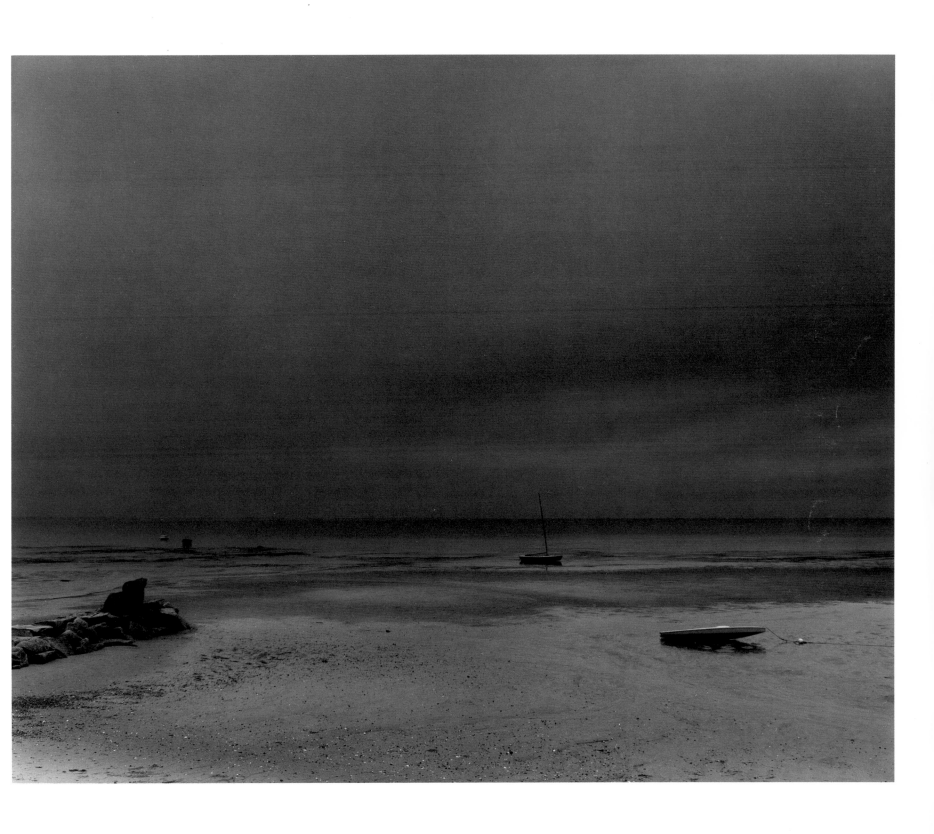

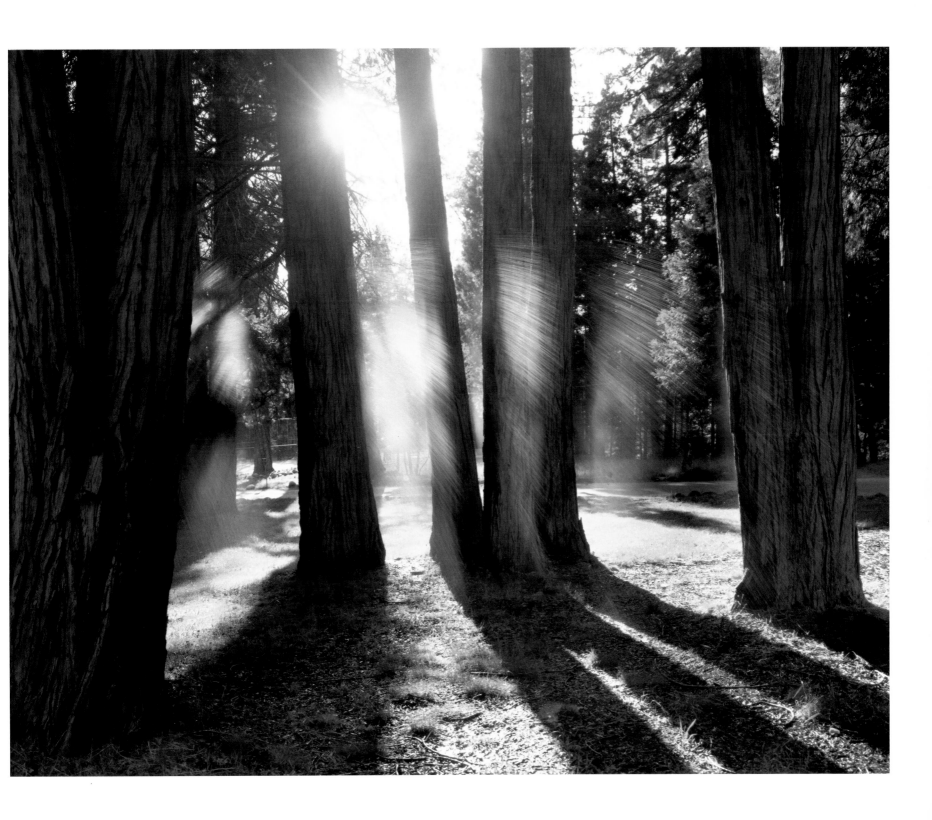

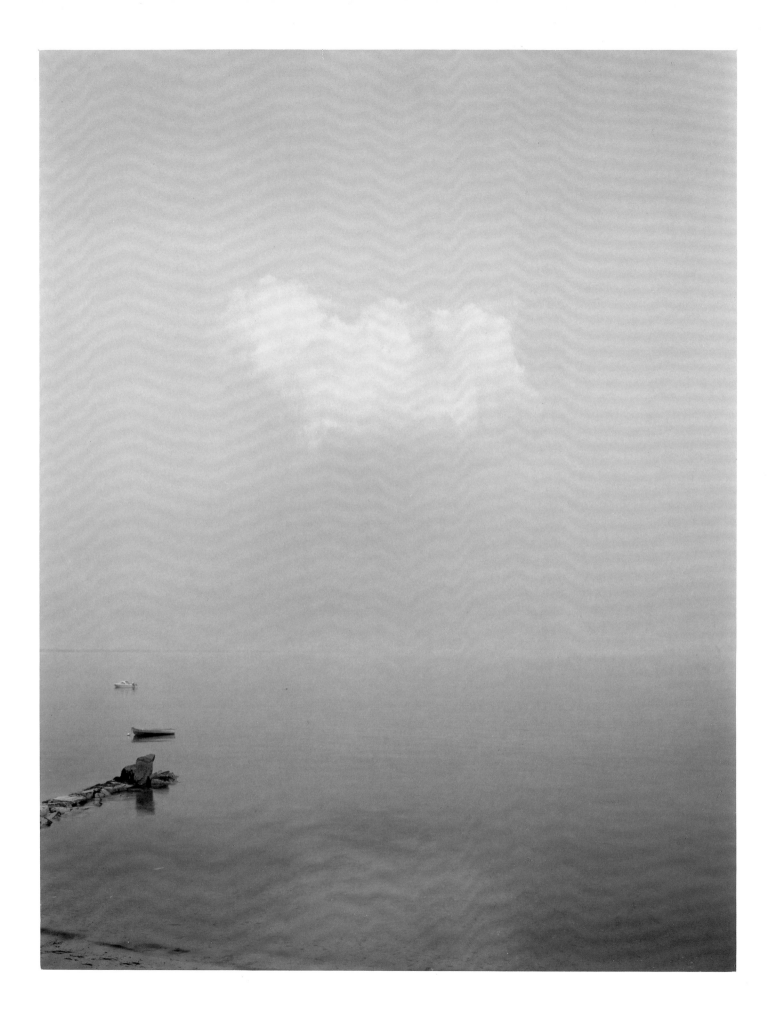

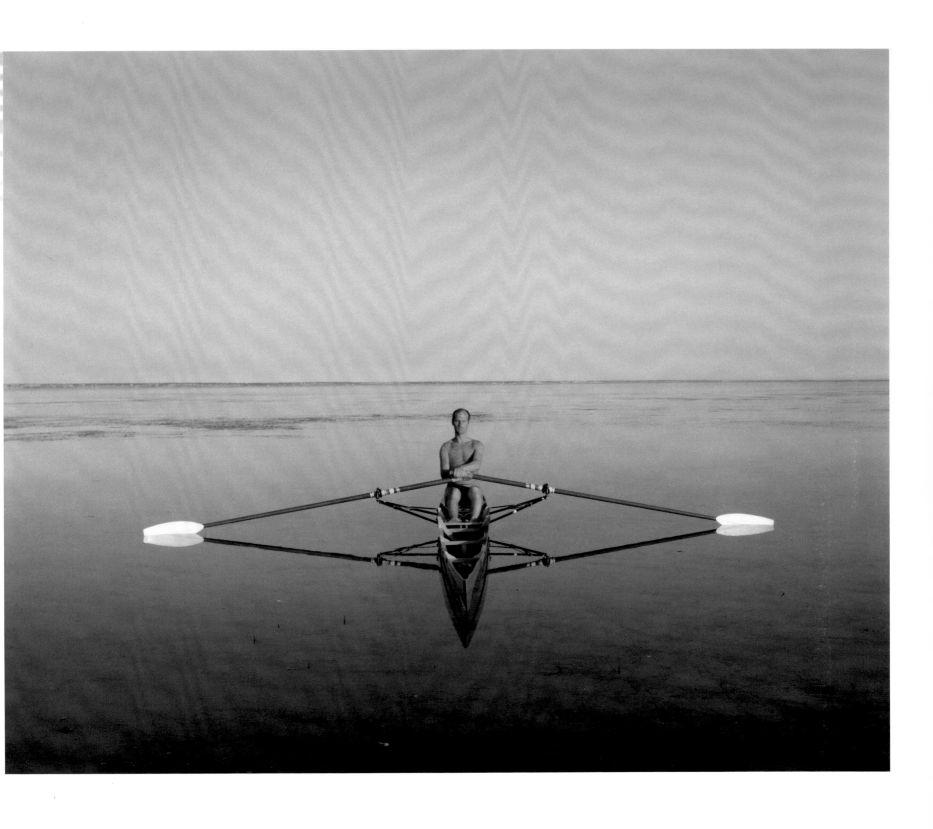

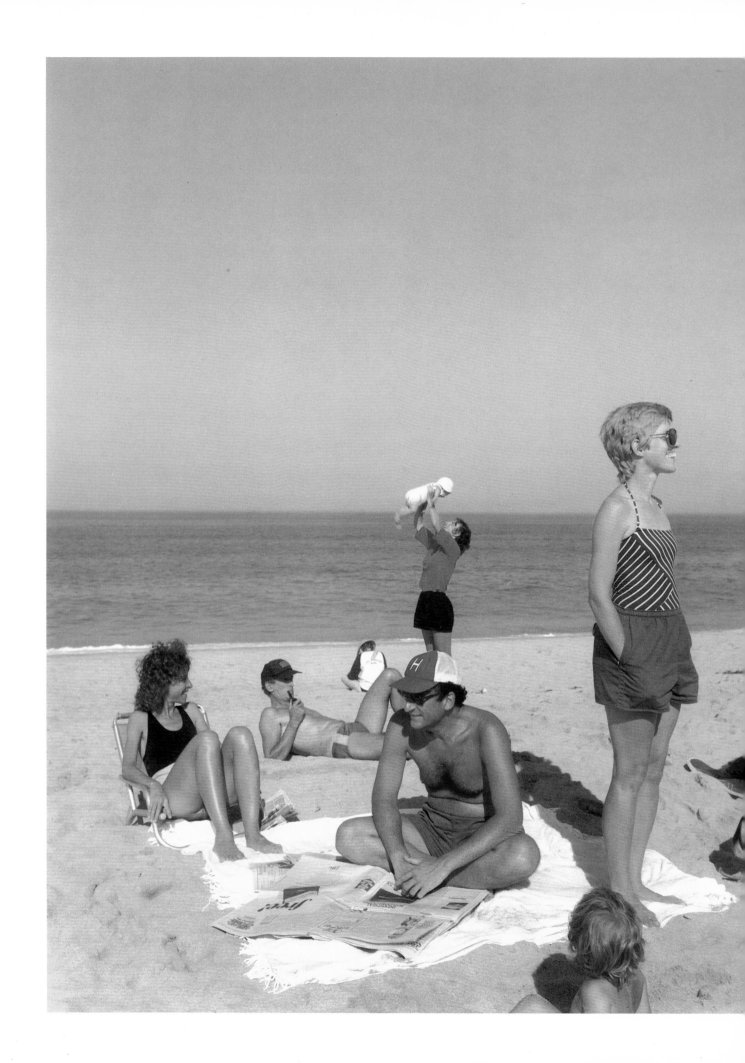

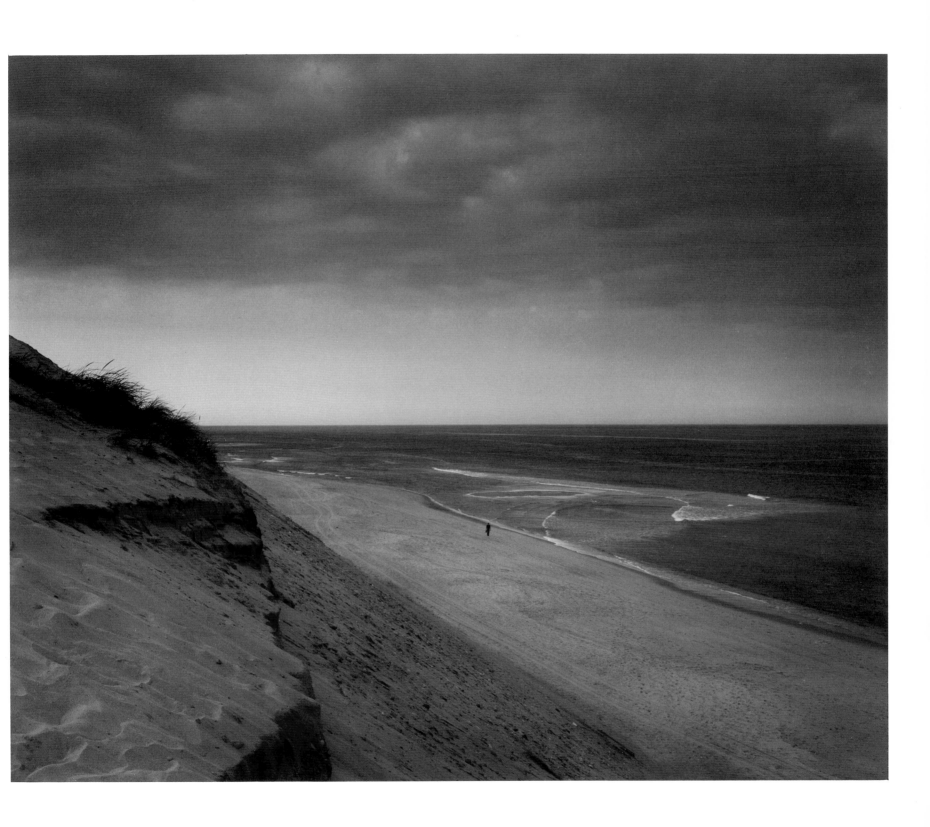

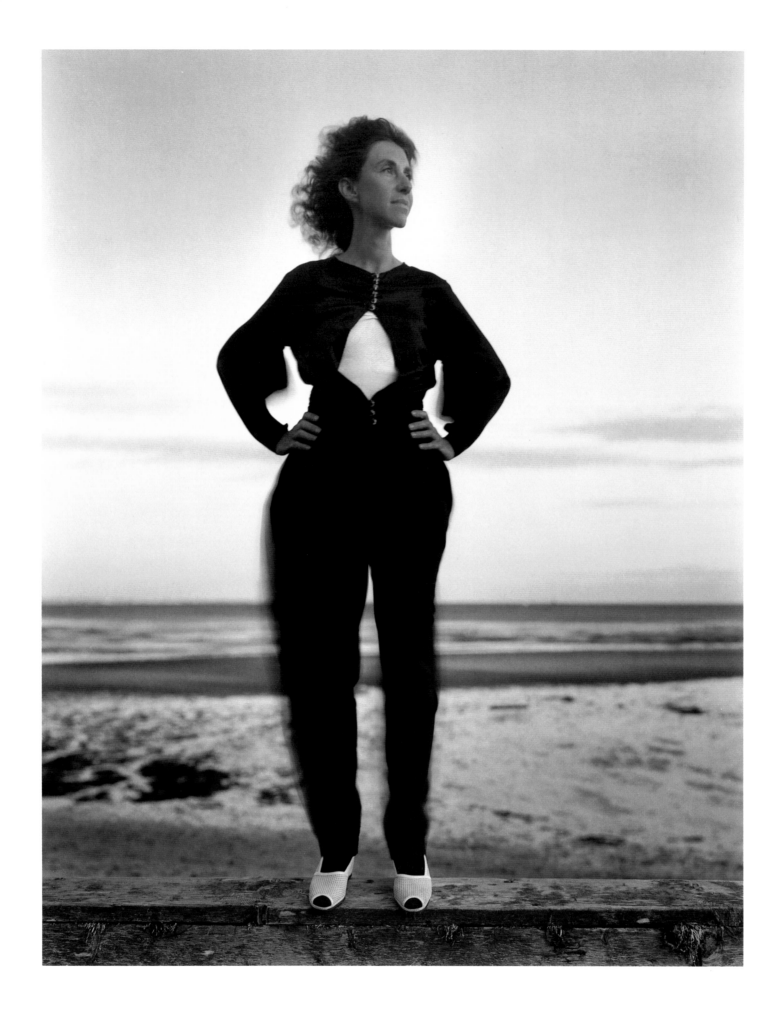

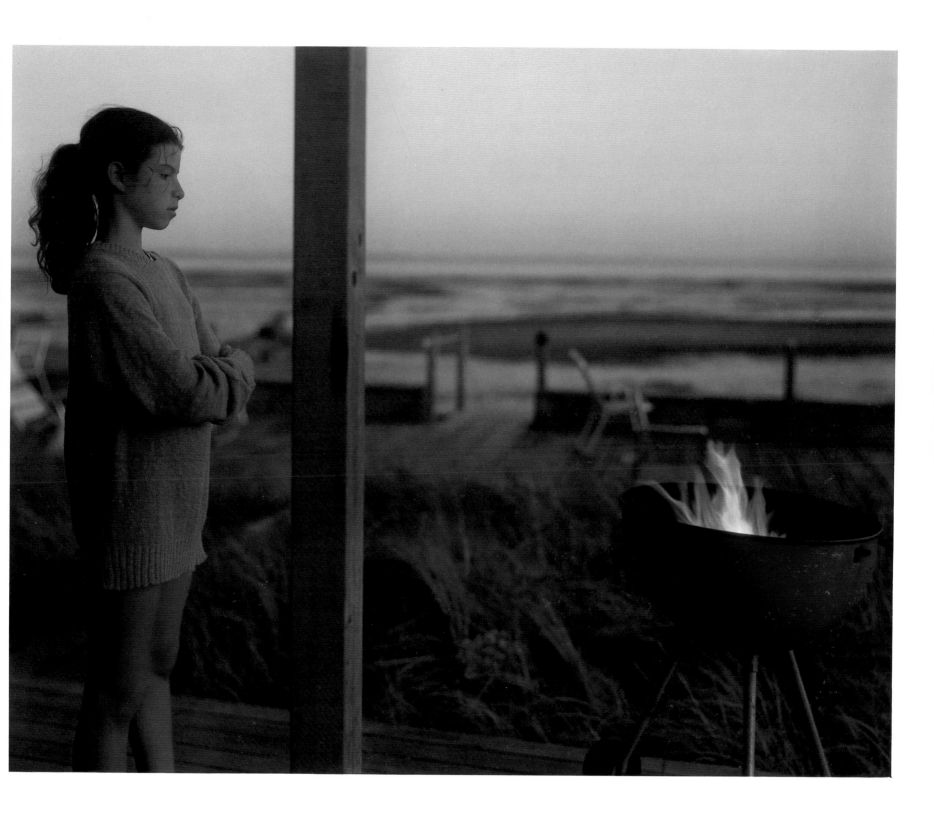

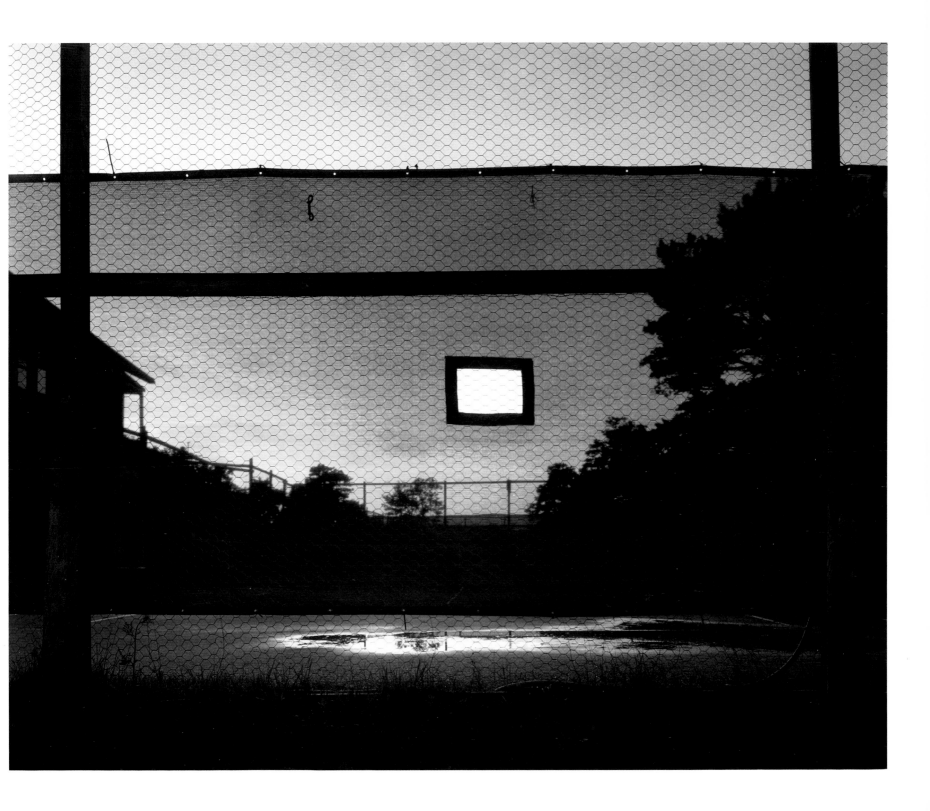

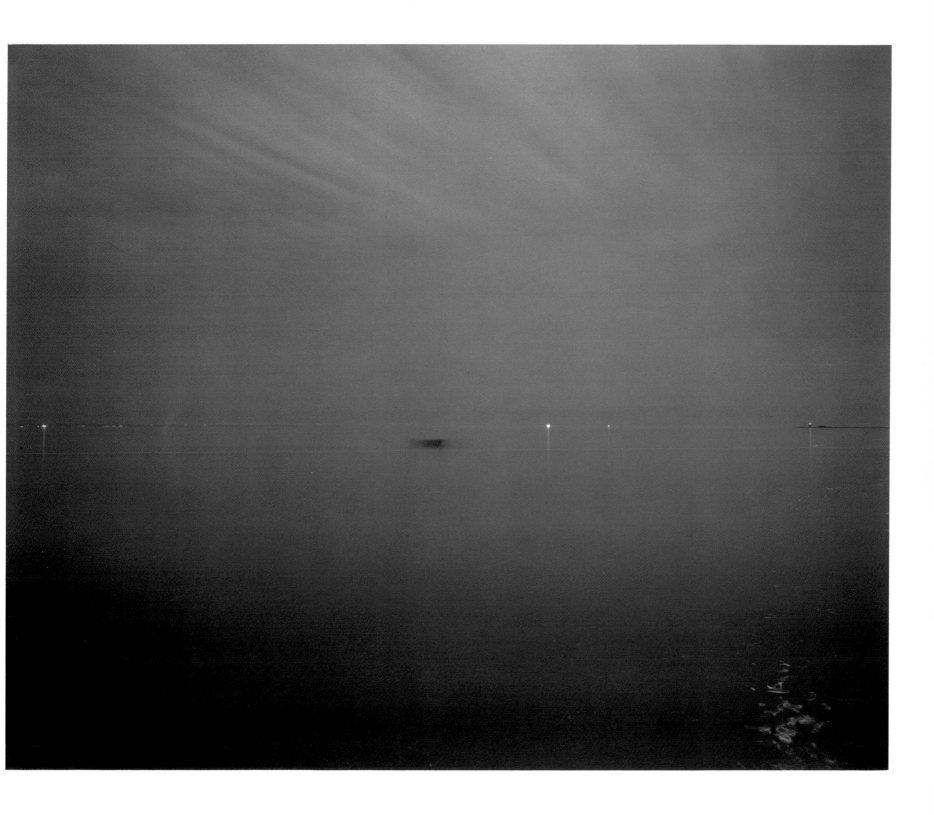

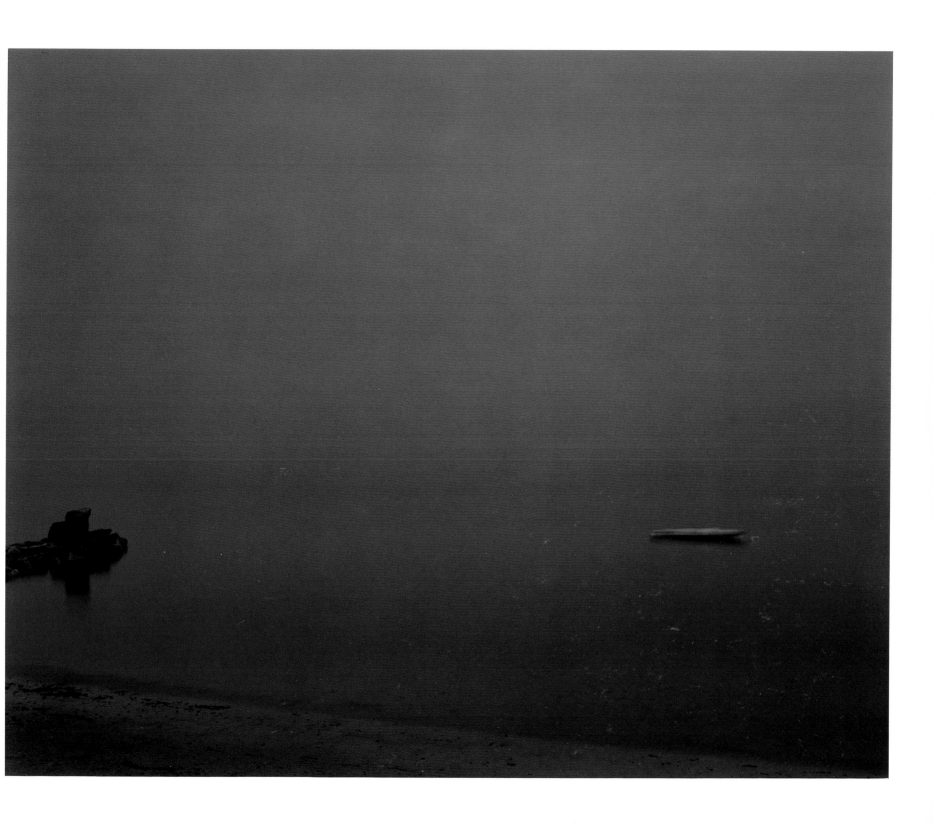

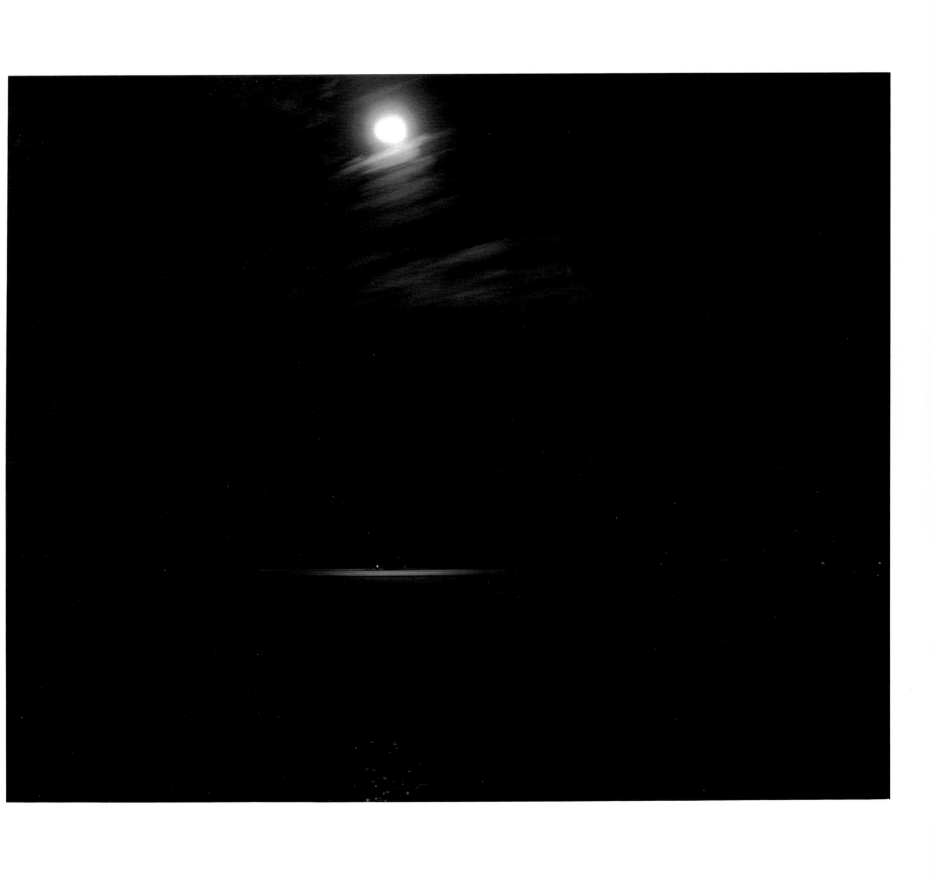

and colored its way across it; rain dripped and jeweled on the screen; insects wandered and wove their paths through it; planes and clouds and shadows were trapped in the squares and frame of the screen; people entered and left. The world was a theater on my screen.

The afternoon is drifting toward the long, golden hours. I grab my glove, climb out the window, and drop the six feet to the street. The guys are on the move; the unspoken call to the ball field is heard. The heat feels good on the back of my arms. Across the street the infield glitters in a mixture of broken glass and mica; you don't want to slide! I trot onto the field and step into my position; it's good to have a place you've earned. I look over at my shortstop — quick hands, the playmaker. Second and first, speed and reach. Playing baseball is one of life's great lessons! The solid whack as the ball jumps off the bat; you move on instinct; sound and motion combine to send you to the right place at the right time. The ball skips into the pocket. Hard contact! Perfect! Even though it's all happening fast, you can experience it as if in slow motion. Time is flexible if you care to see it that way. I watch my teammates. Like a clockworks, we all move together. Our timing, hinged on fractions of a second, is precise, yet contains enough time to hold the ball, lovingly feel the stitches, hesitate, watch, extend the decision to throw just long enough to see it all, to give it tension and beauty and then to hum the ball across the infield and beat the runner by a step. Watching and acting in the same moment, moving in harmony with others, taking all the time you need for completion — these are gifts that discipline provides.

The light slowly draws out of the day. Someone's mother calls, and we all head for the table.

Memories, photographs. I pile them up print after print, day after day, summer after summer, building up a skein of images with which I weave a braid of time, past under present, now over then. Even now, years away from my childhood on the streets of the Bronx, I hear the echoes of summer. Those moments each of us carries in his own way, yet shares. A screened porch; a sudden storm passing and leaving that starched, fresh smell in the air; the warm body of a peach in your hand; a freckled girl; the wildness of rose breath in the evening; that slant of light falling on your bed, telling you how late the summer is....

"Hey, Jo-wul" — dinner's over — "c'mon out." Music to my ears. Ahead of us the night will be filled with games. The chase was on. Ring-a-levio, kick-the-can, hide-and-seek — young gods in their glory streamed from the tenements and gathered on the ash heaps. Olympus in the Bronx. The hour between the dog and the wolf was approaching. We begin to change from those obedient children our parents know into the frenzied packs and hunters of the night. We race through the alleys in the darkness, baying in chorus or alone at street light, moon light, car light, stealthily watching lovers, peering in windows, shadowing parents on their walks. The street's our circus of life. We run till we're exhausted, and then we part.

I stand panting, glistening in the darkness of the empty lots, listening to my heart pound, looking at the light in my window across the gulf of the street, wishing that summer would never end.

Joel Meyerowitz

• LIST OF PLATES •

The photographs in *A Summer's Day* were made with an eight by ten Deardorff view camera equipped with a ten-inch Wide Field Ektar lens. The images were made on Kodak Vericolor II and Fujicolor eight- by ten-inch sheet film. The prints were printed on RC Ektacolor 74 paper.

I wish to thank Joanne Mulberg, Pat Bates, Ralph Senzimici, and Bob Korn for their assistance, patience, and finesse in the printing of the original photographs. To Floyd Yearout, Roger Straus III, and Alan Siegel, I am grateful for their commitment, advice, and belief in this work; and to Murry Reich, who was with me on all those summer days.

Joel Meyerowitz